MODERN ART JOURNAL

MARY RICHARDS

TATE PUBLISHING

Art books don't often encourage you to write or draw in them.
However, this one is yours to make your own. Feel free to
fill in the activities, make your own notes, lists or doodles and cover the
pages with your own art and creative ideas — whatever you like!

As you read through, you'll discover sixteen artists from around the world
who worked from the early twentieth century onwards.
They are arranged in chronological order according to their date of birth.
Many of them are still alive and making art today. At the end
of the book you'll find biographical details of all the artists and a list
of the featured artworks.

Each chapter begins with a quote by the artist, a short introduction
to their work and three words that you might use to describe their art.
Words that are particularly important are highlighted in bold text.

The activities in this book are designed for a broad range of readers.
Some ideas are for you to do on your own with just a few pens or pencils,
and others might require some help from friends and family.
But remember: there are no right or wrong answers, so you can use
this book exactly as you want to!

WHAT'S INSIDE?

'A line is a dot
that went out for a walk.'

Paul Klee was born in the village of Münchenbuchsee near Bern, Switzerland, in 1879. As a boy, he was a talented violinist, but he loved art too. He spent hours drawing characters, plants and landscape views.

After studying painting in Munich, Germany, Klee tried to make a living as a painter. But it was tough! In 1914 he went on a trip to Tunisia in North Africa with some artist friends. Here he was inspired by the intense **light** and **colour** he saw around him. Eureka! He wrote in his diary that he finally knew how he should paint.

In 1921, Klee was invited to teach art at the **Bauhaus** school of art and design in Germany. It became one of the most famous art schools of all time. Teachers and students lived together, exchanged ideas and created artworks. Klee was a great teacher! He gave **lectures** and wrote about art in his notebooks and diaries. His thoughts about art have gone on to inspire many artists.

GEOMETRIC

BOLD

INVENTIVE

TAKING A DOT OUT FOR A WALK...

Traditionally, paintings and sculptures had subjects that were easy to identify. Artists might paint a **portrait** of a person; a view of an outdoor scene (called a **landscape**); a picture of an event in history (a **history painting**); or a collection of objects set up in their studio (called a **still life**). In the early twentieth century, Klee and other modern artists began to create scenes that did not look like anything in particular. We call their art **abstract**.

ABSTRACT ART

Abstract artists create a mood with colours and shapes, in the same way that a composer uses musical notes. They use colours, textures, lines and shapes, but they do not usually produce a picture that looks like an actual person or object.

What did Klee paint?

> Landscapes
> Animals - particularly fish, cats and birds
> Pictures made from geometric shapes - squares, circles and triangles
> Details from nature - flowers, plants and trees
> Characters - both invented and based on real people
> Patterns and grids
> Small dabs or blobs of colour

PICTORIAL ARCHITECTURE RED, YELLOW, BLUE (1923)

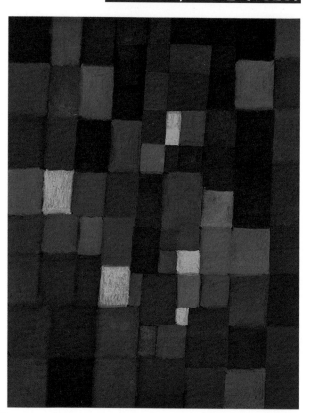

The cubes in Klee's picture look a little like bricks - perhaps he's saying that we can 'build' a painting from small parts, like a piece of architecture.

8

Klee thought hard about the way artists make pictures. He once described drawing as taking a dot 'out for a walk'. An artist takes a pencil, and draws a dot on a page; from this point, he moves the pencil along the paper to create a line. Together, all the lines join together to make a picture.

Why not take a dot 'for a walk' like Klee in the space below? Don't think too hard – just follow your line!

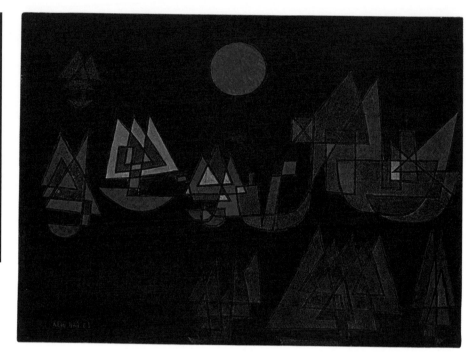

SHIPS IN THE DARK (1927)

SHAPES AND COLOURS

Look at Klee's painting above. Think about all the different parts of the picture. Can you make out any of the ships Klee mentions in his title?

Think about how Klee has worked with shapes. What shapes can you see? What kind of lines has he used — are they straight, curved or a mixture? Can you see any patterns? Make your notes below.

The Bauhaus

In the 1920s the Bauhaus was Germany's most famous art school. The artists and students there were very playful. As well as making art, they enjoyed putting on theatre performances, playing games, dressing up and holding 'costume parties'.

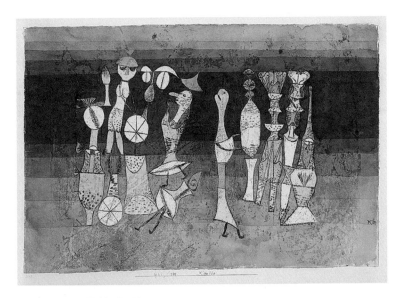

Klee made this picture soon after he arrived to teach at the Bauhaus. It features a group of figures made of different lines and shapes. Perhaps these peculiar characters were inspired by the playful costumes worn by his Bauhaus friends.

COMEDY (1921)

Have you ever thought of designing costumes for a play or for a party?
Sketch some ideas here. You could base them on geometric shapes, like Klee.

Pablo Picasso

'I paint objects as I think them,
not as I see them.'

During his long career, Pablo Picasso worked in many different styles and produced thousands of works of art. He was born in Málaga, Spain, in 1881.

Picasso loved art from a young age. He studied painting in Barcelona and then Madrid. In 1904, he moved to **Paris**. Here, he made friends with a large group of artists, writers and poets. They were all penniless, living and working in run-down studios – but they had some great ideas! Picasso threw himself into Paris life, visiting its cafés, bars and theatres. He also became fascinated by displays of **African masks** and **sculpture** that he saw in the city's museums.

Around 1907, with the painter Georges Braque, Picasso created a style of art that became known as **cubism**. Picasso's cubist pictures were rather like **puzzles**. They challenged people to look at them carefully and come up with their own meanings.

JUMBLED UP

CHALLENGING

BRIGHT

WHAT'S IN THE PICTURE?

What did Picasso paint?

> People on the streets who were sick, injured or homeless (this was called his 'Blue' period)
> Harlequins and circus acts (his 'Rose' period)
> Bottles, guitars, violins and newspapers
> Portraits of people he knew
> Bulls and bullfighters

CUBISM

Cubism changed the way people looked at art forever! Instead of painting objects in a realistic way, the cubists painted things like violins, bottles and guitars broken up and scattered in pieces across the picture.

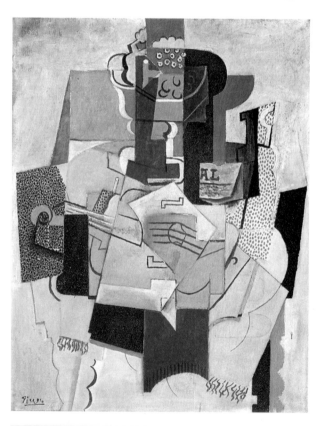

BOWL OF FRUIT, VIOLIN AND BOTTLE (1914)

The Still Life

For centuries artists had been painting still-life pictures of ordinary objects. They could show off their skills by painting them in a realistic way. Picasso and the other cubist painters, however, changed the rules by jumbling everything together.

Look at this picture. Can you spot the items mentioned in the title? Some of them are hiding in more than one place!

Picasso often made **collages** by cutting out pieces of paper or newspaper and sticking them on the canvas. He hasn't stuck paper on this picture – but he has suggested it with paint.

Can you find part of a newspaper in this picture? (Clue: *Journal* is the French word for newspaper.)

Set up a group of objects on a table. You could choose the kind of objects Picasso painted, such as bottles, bowls, fruit or musical instruments.

Then sketch your picture below. Try using sharp, spiky lines, like the cubist artists.

LOOKING AT SPACE

The way things are arranged on the canvas or paper is called a **composition**.
Things are arranged in **space**. Sometimes pictures look **flat**, other times
they appear to be **three-dimensional** (meaning they have **depth** and **volume**).

WEEPING WOMAN (1937)

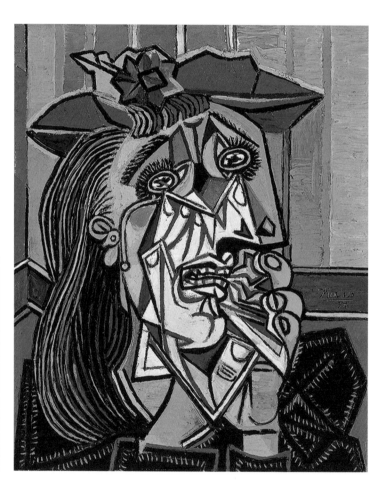

Picasso painted this picture of a woman crying. He wanted to create
a scene showing the horrors of war. But look at the way he has painted
her face! He has used geometric shapes and bold lines – her face looks
as if it might be shattered, like a piece of glass.

16

Can you create a cubist portrait here? Be playful! You could mix up all the parts of the face and even include views from different angles.

Marcel Duchamp

'I don't believe in art.
I believe in artists.'

As a boy, Marcel Duchamp loved drawing cartoons, playing chess and inventing games. He grew up in Normandy, France, and went on to study art in Paris. At first, he was a painter, and artists such as Picasso, who were wowing the city with their unusual paintings, inspired his early pictures.

In 1915, Duchamp moved to New York and became involved with the **Dada** art movement there. Duchamp was interested in **games**, **jokes** and poking fun at the art world. In one of his pictures, he scribbled a beard and moustache on to a photograph of Leonardo da Vinci's famous painting the *Mona Lisa*.

The pieces Duchamp made challenged people to think about art in new ways. From 1913, he made a series of sculptures called **readymades**. What a peculiar collection of objects! They included a bottle rack, a wheel from a bicycle and a metal snow shovel. These were works that were 'made' already – he did not need to create them with his own hands, like a traditional sculptor.

REBELLIOUS

THOUGHT-PROVOKING

STRIKING

WHAT'S THAT DOING IN A GALLERY?

Look closely at Duchamp's *Fountain*. This 'readymade' sculpture caused quite a storm when it was entered into an art competition in New York in 1917. Duchamp made the work from a urinal that he bought at a bathroom showroom in New York. He turned it on its side, and signed it 'R. Mutt' (a fake name).

DADA

Dada artists wanted to challenge the art world and break the rules! The movement began in Switzerland during the First World War, and continued when many of the artists involved moved to New York.

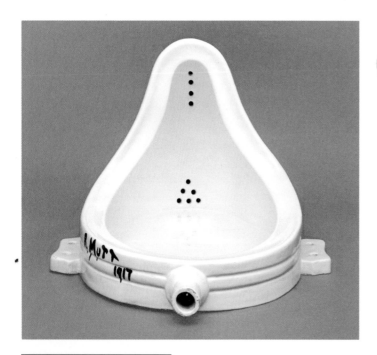

FOUNTAIN (1917)

How did Duchamp challenge the art world?

> By making art from everyday objects.
> By creating unusual ways of showing art in a gallery – he hung sacks of coal from the ceiling, and filled a room with string that was wound around so thickly that it was hard to get through!
> By making many copies of work he'd made before.

In a bathroom shop, *Fountain* is just a toilet, but in a gallery, it's art! What do you think – is it a toilet, art or both? Do you like it? Has Duchamp changed the object in any way?

Look around your house. What objects could you imagine putting in a gallery – and why? Write your list here.

PLAYING WITH ART

Duchamp loved playful puns, word games and riddles. Hundreds of examples can be found in his notes, diaries and letters. For example, he swapped the sounds of his name around [Mar-cel Du-champ] to create Marchand du Sel – which means 'salt seller' in French.

Play around with your own name, and the names of your friends.
Can you make any jokes, anagrams or new words?

In the 1940s Duchamp began making miniature versions of his work, which he packed into small leather cases. By doing this he was questioning the importance we place on original works of art – he said that he was interested in ideas, rather than objects.

BOX IN A VALISE (C.1943)

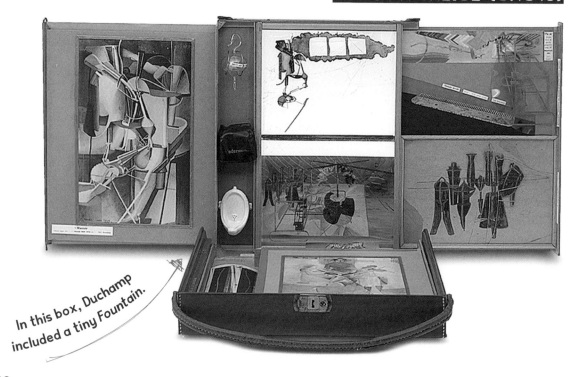

In this box, Duchamp included a tiny Fountain.

Fill this suitcase with works of art. They could be pieces you've invented or works you've seen in a gallery. If you like, you could choose a theme to connect them.

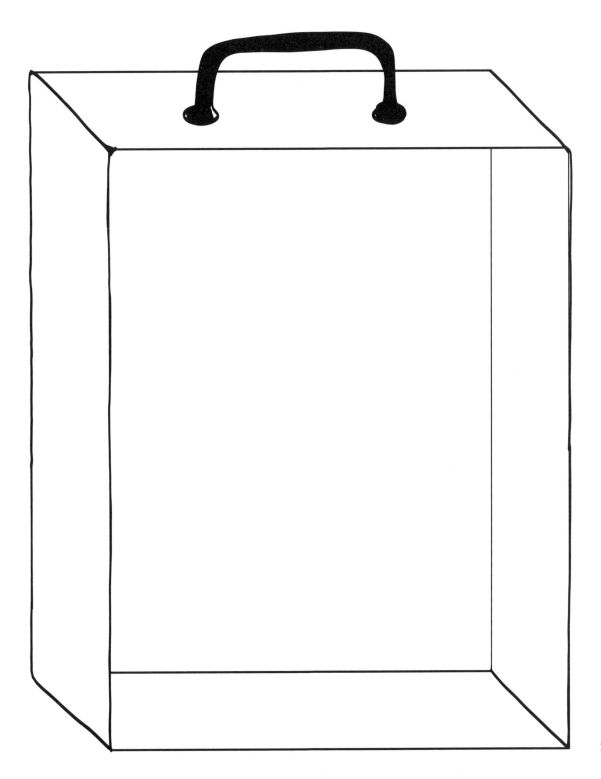

René magritte

'The mind loves the unknown.
It loves images
whose meaning is unknown,
since the meaning
of the mind itself is unknown.'

After studying at art school in Brussels, Belgium, René Magritte took various jobs to earn money, including designing wallpaper and fashion advertisements.

Rather like the commercials we see on TV, Magritte's bold paintings grab our attention and stop us in our tracks. In his work, ordinary, everyday things such as apples, wine glasses or a man in a bowler hat are placed in **strange settings** or in **unexpected combinations**. They are painted in a very **realistic** way, which makes the scenes seem even more **peculiar**. You can hardly believe your eyes!

Magritte was a member of a group of artists and poets called the **surrealists**. In 1927 he joined them in Paris, staying for three years. When Magritte moved back to Brussels, it wasn't always easy to make ends meet. He set up a design studio with his brother, and at one point he even earned money by forging paintings by other artists! By the time Magritte died in 1967, however, he was very popular. His work was shown in exhibitions across the world. Ever since, the pictures he painted have inspired artists, designers and filmmakers.

SURREAL
EYE-CATCHING
PLAYFUL

OBJECTS MADE STRANGE

What did Magritte paint?

> Familiar objects - such as pipes, apples, eggs, birds, clocks or candles
> Men in suits and bowler hats
> Blue skies with clouds and views of the sea
> Windows and doors, picture frames and mirrors
> Pictures of artists, easels or paints

THE RECKLESS SLEEPER (1928)

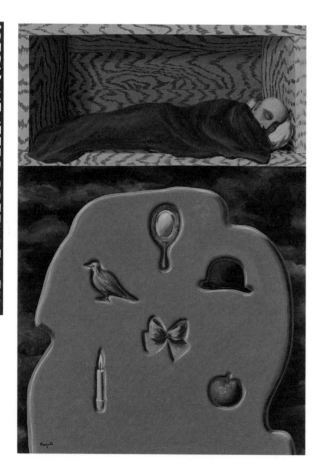

SURREALISM

The surrealists celebrated the power of the imagination! They playfully combined images and words that would not normally be found together. They wanted to make their art from the 'unconscious' - the thoughts or feelings they believed were buried deep in the brain.

Thinking about dreams

The surrealists were very interested in dreams, because when you dream you cannot control what happens. Long-forgotten images can suddenly come to the surface; everything is jumbled up, leading to new and unexpected ideas.

Take a look at this picture by Magritte. A figure covered in a red-brown cloak lies with his eyes closed, in what looks like a wooden box. Could he be asleep and dreaming? Or could this be a coffin? Below him we can see a group of different objects that are pressed into a grey shape, which looks a little like a tombstone.

Which objects can you see in the picture and why do you think Magritte might have included them? What might connect them? Remember, in dreams, things don't have to make sense!

Plan a short story about the man in the picture.

SURREAL GAMES

THE EMPIRE OF LIGHT (1954)

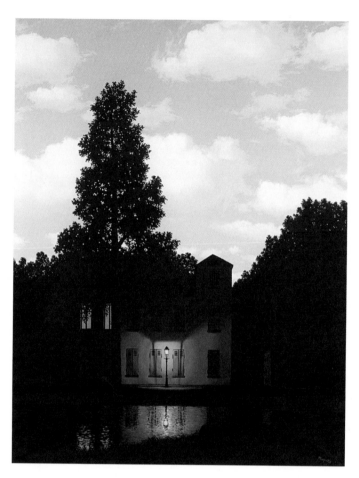

In Magritte's picture, the buildings, trees and streetlamp tell us it's night-time – but the bright blue sky suggests broad daylight. Impossible! But Magritte enjoyed making familiar scenes seem strange.

The surrealists liked to create art and writing by working together as a group. They enjoyed making art and texts in a random way. Try out these activities to get into the minds of the surrealists!

**Stare at an object for as long as you can. Focus on it carefully.
What thoughts come to you? Write down whatever springs to mind.**

Draw a friend's portrait here, but do it with your eyes closed.
Don't look at the paper until you're finished!

GAMES WITH WORDS

Find a newspaper. Cut out sentences (or parts of sentences) at random.
Then stick them together here to create a new story.

Sit down with a friend and find a book. Take it in turns to point to a word and note it down. Repeat, until you have a good collection of words. Then write a story together using all the words you've found.

Strange combinations

In the first space, ask a friend or family member to name an animal; in the second space, ask someone else to name an action or activity; then, in the third space, write down another animal.

	ANIMAL	ACTIVITY	ANIMAL
A	crocodile	having lunch	with a baboon
A			with a
A			with a
A			with a
A			with a
A			with a

Draw the results here!

JOSEPH CORNELL

'Dreams
ever different
ever varied
endless voyages
endless realms
ever strange
ever wonderful.'

Joseph Cornell never trained as an artist – he actually worked as a textile salesman! He lived with his mother and younger brother in New York, but spent all of his spare time going to the cinema, theatre, bookshops and museums.

Cornell loved **collecting** things! He filled his house with books and encyclopedias, magazine cuttings, diaries and newspaper articles on lots of different subjects.

One day, while visiting a New York gallery, Cornell spotted some collages by the German artist Max Ernst. He raced back home and started **cutting out pictures** from his magazine collection, sticking **strange and unusual images** next to each other. These artworks were shown at the same gallery the following year, next to works by Picasso, Duchamp, Ernst and Salvador Dalí.

During the 1930s, Cornell became well known for his art. As well as making collages, he started making **boxes** filled with **weird and wonderful objects** from his collection.

WHAT'S IN THE BOX?

To create his art, Cornell used small cardboard jewellery and pill boxes, and old wooden chests or drawers that he had bought in junk shops. Sometimes the boxes already included different compartments, which he filled with objects. He loved including moving parts, interesting surfaces and textures, and building up layers upon layers. Sometimes he hid things in secret compartments!

UNTITLED (HOTEL DE LA DUCHESSE-ANNE) (1957)

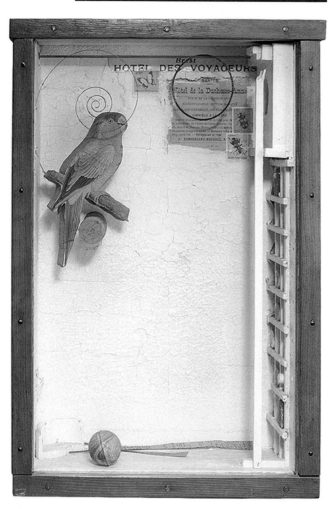

This box is from a series Cornell called 'aviaries' (bird houses). The work's title is the name of a French hotel, which is printed on a newspaper clipping stuck to the back of the box. You can also read the name of another French hotel at the top of the box - 'Hôtel des Voyageurs'.

How has Cornell arranged the objects inside the box?

Can you connect them? For example, what might tropical birds have to do with foreign stamps?

Would you like to put it on your wall?

Start your own collection! What objects would you bring together?

Can you think of a theme to link them?

Draw them here, in this cabinet inspired by Cornell.

AWESOME COLLECTIONS

Cornell often dedicated his 'box' pictures to people he admired.
This one was for Giuditta Pasta, a nineteenth-century Italian opera singer.
He included images of planets, astronomy and maps. They might mean
that she was a 'star', with a 'heavenly' voice.

What did Cornell collect?

> Magazine cuttings
> Photographs of theatrical and musical stars
> Pictures of works of art
> Opera and theatre programmes
> Books, records and printed music
> Maps and charts
> Glasses and china, small bottles and jars
> Toy figures and dolls
> Marbles, wooden blocks and balls
> Natural things – feathers, pieces of grass, birds' eggs, sawdust, bark, shells and driftwood found on the beaches of Long Island

Choose someone you admire — it could be a film or pop star, or someone you know. What would you include in a box you would make for them?
Think of a reason for choosing each object.

Person:

Object:

Reason:

Object:

Reason:

Object:

Reason:

Object:

Reason:

Object:

Reason:

FRIDA KAHLO

'I never painted dreams.
I painted my own reality.'

Frida Kahlo was born in 1907 in Coyoacán, Mexico. As a child, she always enjoyed drawing and painting, but her great dream was to become a doctor. At the age of eighteen she was badly injured in an accident. While recovering, she had to spend long periods of time in bed. Life was a struggle, but, looking up at a mirror fixed above her bed and using a special easel, she began creating incredible **self-portraits**.

Kahlo married one of Mexico's most famous painters, Diego Rivera. The pair lived together in the house she grew up in, called the **Casa Azul** ('Blue House'). In their garden they grew tropical plants and displayed their collection of ancient Mexican sculptures. Kahlo's pets roamed around the gardens. She looked out at all of this from the studio where she worked. The **leafy plants, exotic fruit** and **animals** filled her paintings.

Kahlo and Rivera travelled to New York and Paris together, showing their work and meeting other artists and collectors. Although Kahlo had exhibitions in her lifetime, it was not until after her death that she became world famous. She is now celebrated not just as an artist, but also as a writer.

PERSONAL

DARING

COLOURFUL

PICTURING HERSELF

What did Kahlo paint?

> The tropical flowers and leafy plants growing in her garden, such as cacti, agave, prickly pear and fruit trees
> Traditional Mexican folk costumes - lace skirts, ribbons, floral patterns, jewellery
> Her own face
> Her pets
> Rocks, shells, bones, skulls and other strange objects from her collection
> Suns and moons
> Ancient Mexican art objects, which she collected

Kahlo painted this picture of herself with her pet monkey, Fulang Chang, in 1938. She kept many other pets, including dogs, fawns and parakeets.

Kahlo was also passionate about Mexican history. She often gave her birth date as 1910, the date of the Mexican Revolution. She wore traditional clothing to show her links with the past, and collected the art of Mexico's ancient civilisations.

Kahlo turned everything she wore into a work of art. She decorated her plaster casts and corsets, and even her prosthetic leg.

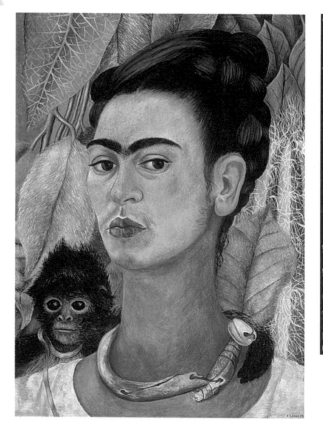

SELF PORTRAIT WITH MONKEY (1938)

Here are some examples of traditional Mexican clothes like the ones Kahlo wore.
You could colour them in — and add your own designs too!

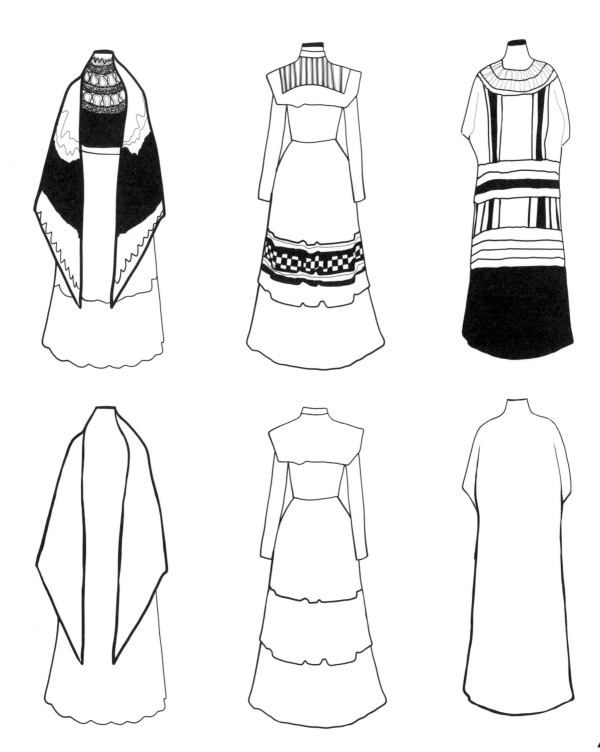

SELF-PORTRAITS

Look at the picture closely. What is Kahlo wearing?

How has she styled her hair?

What is she wearing around her neck?

What's in the background?

What else can you see in the picture?

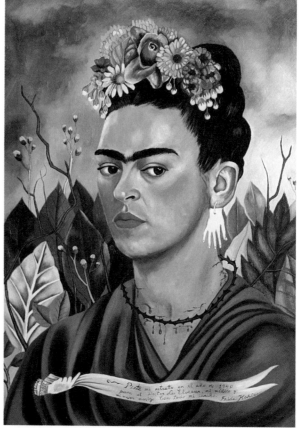

SELF PORTRAIT (1940)

Plan a self-portrait. Look at your features carefully in a mirror.
You could also include some of your favourite belongings in the picture.

What would you include, and why? Make a list here before drawing the picture.

Draw your portrait here.

Louise Bourgeois

'Tell your own story
and you will be interesting.'

Louise Bourgeois was born in Paris on Christmas Day, 1911. She grew up in a large house just outside the city. As a young girl, Bourgeois enjoyed being in her parents' busy **tapestry** studio, helping with dyeing cloth, weaving and sewing. She would often draw designs for tapestry sections that needed to be repaired. She became quite the expert at **drawing hands** and **feet**!

But life wasn't always easy. As she got older, Bourgeois wrote about many sad things that had happened in her **childhood** – the horrors of the First World War, her mother's illness and her parents' troubled marriage. She collected all these **emotional memories** and used them to tell **stories** in her art.

Bourgeois started out as a painter, but when she moved to New York she started making **sculpture**. She created her first pieces on the roof of her home. They were **towering** stacks of wood inspired by the skyscrapers she saw all around her. As her sculptures got bigger, she expanded into a large studio. Here, she was able to make dramatic sculptures that sometimes **filled whole rooms**. Her career stretched over seventy years! And she was still making art when she died at her home in New York at the grand old age of ninety-eight.

NARRATIVE

MYSTERIOUS

BOLD

THINKING ABOUT MATERIALS

What did Bourgeois use to make her sculptures?

> Scraps of fabric, including her own clothes
> Wood – carved into shapes or stacked to make towers
> Pieces of stone, glass and metal
> Soft materials such as plaster, latex and wax
> Objects from her home and studio – furniture, doors, chairs, mirrors, needles and thread – and even a spiral staircase!
> Unusual things – such as a doll's house or the blade of a guillotine!

CELL (EYES AND MIRRORS) (1989-93)

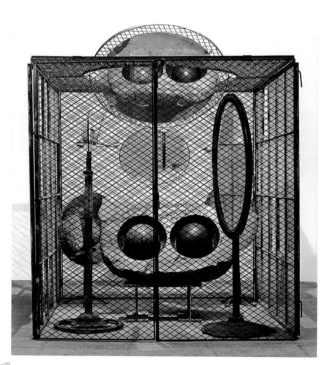

Cells

In the 1990s, Bourgeois started making pieces called 'cells'. These were large sculptures filled with objects she had collected over the years. With their walls, windows and doors, they look like rooms or cages. You can enter some of her 'cells' and look closely at the objects inside, but others you can only look into. Some of them are dark, dramatically lit and a little bit scary!

This 'cell' is made from pieces of wire mesh and panes of glass. Inside, Bourgeois has placed a set of oval mirrors at different angles. As you peer through the mesh, you can sometimes catch a glimpse of your reflection in them. She has placed two 'eyes', which are actually black marble globes, into a large block of stone. They seem to be looking back at you, don't they?

What do you think of when you hear the word 'cell'?

Plan a 'cell' of your own. What would you put in it?

Would you fill it with things from your home?

STORIES OF SPIDERS

Bourgeois loved spiders, and she made hundreds of drawings and sculptures of them throughout her career. She described the spider as an artist. It could spin thread and create magnificent webs. It could also mend things. Remember, Bourgeois grew up in a place where there was spinning, weaving and repairing - her parents' tapestry workshop.

Bourgeois's huge bronze spiders often carry great big sacs of marble eggs. She called many of the sculptures *Maman*, which is French for mother. She once said that she thought of spiders as 'helpful, protective and clever', like her own mother.

Imagine walking into a gallery and looking up to see a giant spider's body and spiky legs towering over you!

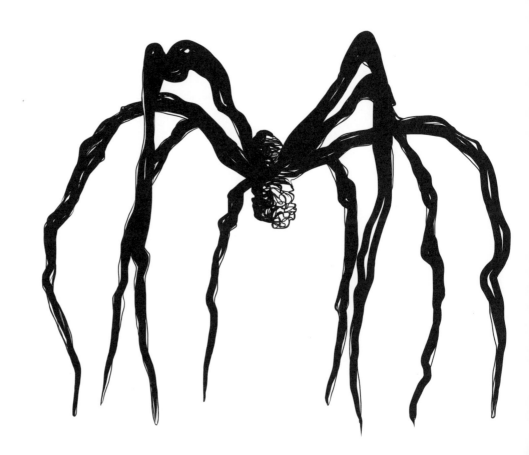

Make a list of the best words to describe spiders. Here's a few to get you started:

Deadly, misunderstood, spindly...

Great! Now look at the words you've chosen and write a spider poem using them.

WRITE IT ALL DOWN!

Bourgeois kept diaries and journals from the age of twelve. When she couldn't sleep at night, she liked to write and draw, recording her feelings and sometimes writing about her greatest fears. Many of the objects, ideas, pieces of art or writing in these notebooks would eventually become sculptures!

Have you ever used a diary to record your thoughts and feelings? Use the opposite page to write your diary entry for today. You could also keep a notebook with you at all times to record your creative ideas and sketches.

Think of something that happened to you today. Now draw or paint it in the space below.

Write today's diary entry here.

ANDY WARHOL

'In the future everyone will be world-famous for fifteen minutes.'

Andy Warhol was born in 1928. He grew up in Pittsburgh, a city in America famous for its coal and steel factories. Warhol was often ill as a child, and spent his time off school reading comic books and collecting autographs of famous **movie stars**. He enjoyed going to the cinema and watching **cartoons** and **films**.

Warhol's art career began when he moved to New York in the 1950s. He soon became successful, designing **advertisements** in newspapers and magazines and even creating **window displays**. Warhol was at the centre of what is known as **pop art**. For Warhol, art could look as if it had been printed or made by a machine. It didn't need to be one of a kind, or show the delicate, careful brushstrokes of the artist.

In one of his first exhibitions, Warhol showed a series of thirty-two paintings of tins of Campbell's Soup on a 'shelf' in a gallery. They were lined up together as if they were in a supermarket display. His huge New York studio was known as the **Factory**, and Warhol and his friends gathered there to have fun, make pictures, listen to music and make films.

INDUSTRIAL

BRIGHT

POPULAR

FACTORY LIFE

Artists, models, actors and musicians came to the Factory to spend time with Warhol and work with him on paintings, films and other projects. Warhol photographed them and made short black-and-white films called 'screen tests'. He asked them to stare straight at his camera for a few minutes, without saying anything.

POP ART

Pop art caught on around the world in the 1960s. 'Pop' was short for 'popular'. Pop artists were inspired by the everyday things they found in the world around them – such as packaging, newspapers, comic books and photos of the stars of TV and film.

What did Warhol put in his art?

> Newspapers – front pages and advertisements
> Magazine articles
> Cartoon characters – Superman, Popeye, Batman, Dick Tracy
> Photos of film and TV stars
> Food packaging, labels and logos – such as Coca Cola, Del Monte Peaches, Campbell's Soup, Heinz Tomato Ketchup, Brillo Soap Pads
> Pictures taken in photo booths
> People in his Factory
> The supermarket

HEINZ TOMATO KETCHUP BOX [PROTOTYPE], 1963-4

Warhol made art from the things he saw in the world around him. His 1964 series of cardboard-box sculptures were made from wood and painted so that they looked like the actual cardboard cartons you find in a supermarket. Of course, they were stacked in galleries, not shops or warehouses!

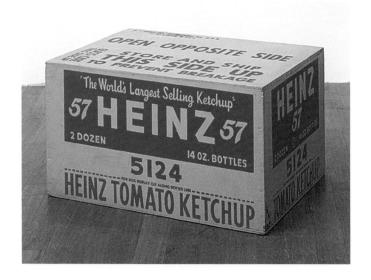

Warhol started his own magazine, called *Interview*.
What would you call your magazine? What would you put in it?

Design the cover here.

OVER AND OVER AND OVER AGAIN

Find a food package from your own kitchen with a bold label that appeals to you and draw it in the first box.

Then experiment in the grid below by repeating the image again and again.

Next time you're in the supermarket, find the aisle containing your favourite food.

Describe what you can see here.

BLACK BEAN (1968)

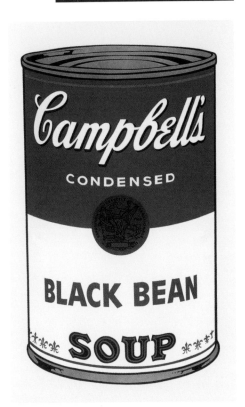

Warhol called his studio the 'Factory' because he said he wanted to be like a machine.
If you had an art studio, what would you call it?

List your ideas here.

'I, Kusama am the original
Alice in Wonderland.'

Yayoi Kusama was born in 1929. She grew up in Matsumoto, a city in the centre of Japan surrounded by mountains. She spent a lot of her childhood outdoors, sketching in the fields around her home.

At the age of ten, Kusama began to experience **hallucinations** (seeing things that are not really there). These visions were often **terrifying** for her and she still suffers from them. Throughout her life, however, she has used art to cope with them.

At first, Kusama's parents didn't want her to become an artist, but she persuaded them to let her study painting. Soon, she moved to New York. She was poor and felt like an outsider, but she managed to find a studio. As well as **paintings**, she began to make **sculpture**. In 1965 she created her first **installation** (a work of art that transforms a gallery space).

In 1973, Kusama decided to move back to Japan, exhausted by life in New York. A few years later, she checked in to a hospital to receive treatment for her hallucinations and has been living there ever since, but she hasn't stopped working! Every day she still goes to her studio nearby to make art, write poems and create books.

INFINITE

DAZZLING

VIVID

INFINITY – WITH NO BEGINNING AND NO END

In her early paintings Kusama painted tiny net-like patterns of loops and swirls.
She called the pictures 'Infinity Nets'. One was 10 metres long.
She worked on them day and night, and couldn't stop.
She even continued her painting on the walls and ceiling of her studio.

Draw some looping, swirling patterns here.

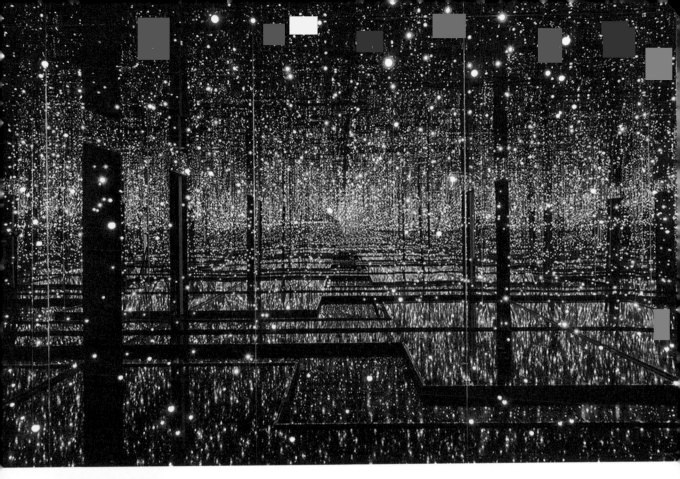

FINITY MIRRORED ROOM (2012)

Gallery visitors can enter Kusama's rooms or installations. They explore the space together, looking at their reflections in the mirrors on the walls and feel the effects of the changing lights, tiny dots that twinkle on and off and change colours. They become part of the artwork!

Kusama is interested in the idea of infinity, which means having no end and no beginning. Why might a room full of mirrors be a good way of exploring this idea?

(Think about what happens to reflections when lots of mirrors fill a space.)

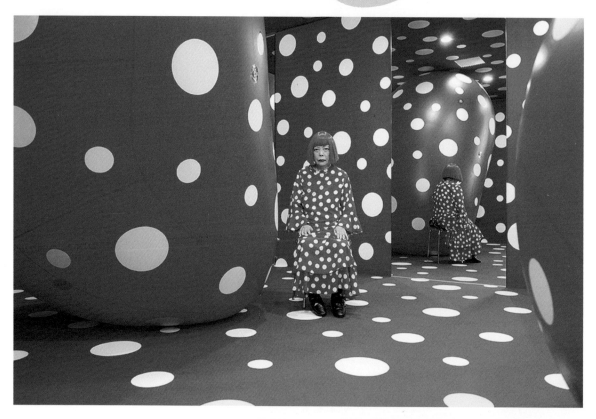

THINKING ABOUT DOTS

Kusama often photographs herself in the spaces she has created. Here, she's dressed in a matching outfit that blends in with the work. It's as if she's disappearing into her installation.

Throughout her life, Kusama's pictures have been filled with dots; she calls this her 'dots obsession' (a title she once used for an exhibition). She said that polka dots are the shape of the sun, 'which is a symbol of the energy of the world', and also the shape of the moon, 'which is calm, round and soft'. Rather like people, who gather together, 'polka dots can't stay alone'.

Write some other words to describe polka dots here.
Here's a few to get you started: spheres, globes, circles . . .

Now, find some words to describe moving dots: flickering, spinning . . .

Stars and planets in the night sky can look like dots of light.
Chicken pox spots might look like polka dots.
Think of some other examples of spots and dots, then write them here.

Can you create a picture here, made only of dots?

Bridget Riley

'Rhythm and repetition
are at the root of movement.'

During the Second World War, the young Bridget Riley, who was born in London in 1931, moved with her mother and aunt to a cottage by the sea. She remembers being fascinated by the colours and shapes she saw in the landscape around her.

Riley studied art in London. In the early 1960s, she became known for paintings made of simple **geometric shapes**. She made them very precisely, experimenting with different combinations of lines, curves, squares, triangles and discs. By repeating certain shapes to form a pattern, she created pictures with **rhythm** and **movement**.

Around 1966, Riley began to use **colour** in her work. At first, she used just three or four colours per picture, arranged in vertical stripes. In 1980, after a visit to Egypt, she started using even more intense shades such as deep blues, turquoises, ochre yellows, oranges and greens. She is interested in the way colours change and take on new effects when they are placed next to other colours in a picture. Her pictures seem to pulse with life!

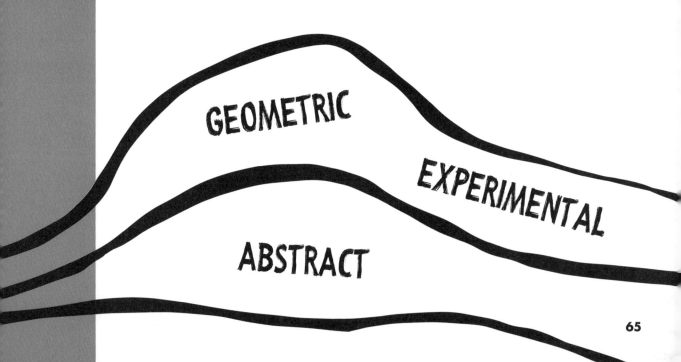

GEOMETRIC

EXPERIMENTAL

ABSTRACT

LINES AND SHAPES

Riley's painting is made of thin black lines. They cascade down the canvas like a waterfall, bending and curling around as they drop. They look as if they are moving on the surface of the picture.

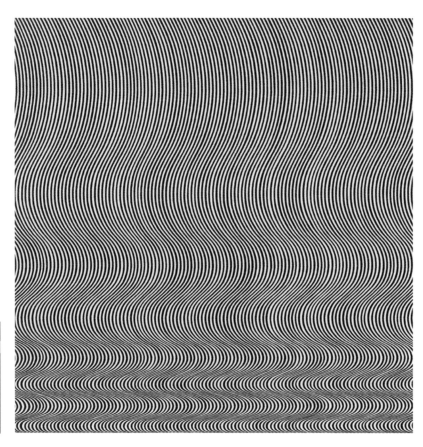

FALL (1963)

Riley talks about lines as if they are moving. Here are some of the words she's used to describe them: moving fast, going slowly, flowing . . .

What other words can you think of?

Use this page to create drawings in black-and-white using simple lines and shapes.

A WORLD OF COLOUR

NATARAJA (1993)

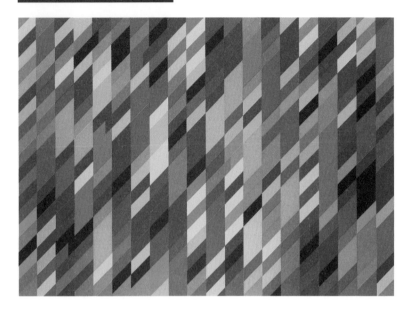

This picture is composed of a set of bold, bright colours. It's possible to make out both vertical and diagonal lines in the picture. Most of the blocks of colour are the same size, but some are a lot larger! 'Nataraja' is a word taken from Hindu mythology. It means 'Lord of the dance', which is one of the names given to the Hindu god Shiva. Here, Riley's colours appear to dance across the surface of the picture.

Look carefully at Riley's picture.
Can you see any patterns in the way she's used colour?
Can you list any shapes she's used?

Choose some words to describe each colour.

Thinking more about colour

Find a colourful magazine and cut out different examples of the same colour:

Once you've found all these colours, you could use them to inspire your own artworks.

A yellow that is warm and one that is cold

A green that is bright and one that is dull

A blue that is dark and one that is light

A red that is vivid and one that is darker

PAULA REGO

'Anything can happen in pictures.'

Paula Rego was born in Lisbon, Portugal, in 1935. As a young girl she spent hours drawing in her playroom at her grandmother's house. She had a great imagination, and remembers that she was 'afraid of everything'. Her parents encouraged her to become an artist, so she came to London to study at art school.

Rego's pictures are often inspired by **stories** – from the traditional **folk tales** and **nursery rhymes** she heard her grandmother tell when she was a young girl to **books** that she has read more recently. Many of her paintings include different **characters**, and some groups of work tell a story that unfolds over a series of pictures.

Rego's subjects are often female. Many of them are based on her model, Lila, who poses for her in her studio most days. Once in her pictures, the characters she creates seem to take on **a life of their own** – it is as if they have their own story to tell. Her studio is full of **props**, some found, some hand-made, stuffed toys, clothes, fabric and other objects. She once said, 'you have to become the figures you're drawing'.

POWERFUL

FICTIONAL

DRAMATIC

PICTURING STORIES

In Rego's painting below, we can see a group of characters gathered on a moonlit beach in Portugal. All the women in the picture are at different stages of their lives. The girl on the left is dancing alone. Two young girls are dancing with men. At the back of the picture three females (perhaps a grandmother, a small girl and her mother) are dancing together. The shadowy night setting makes the picture seem like it could be a dream!

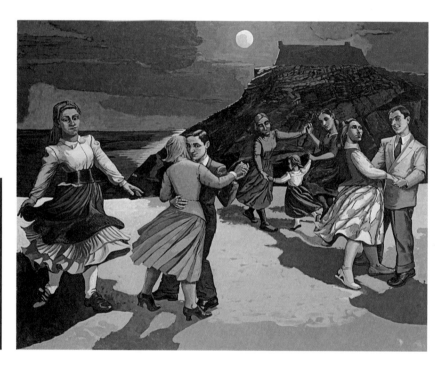

THE DANCE (1988)

**Look at the characters in this picture. Choose one, and invent a name for them.
Describe what they look like. What are they doing on the beach at night?**

Now imagine you are another character from the picture. Write a diary entry describing the scene from their point of view. Include as many details as you can. What are the sights, sounds and smells as you dance on the beach?

COLOURFUL CHARACTERS

Rego was inspired by book characters such as Peter Pan and Jane Eyre.

Write the names of your favourite books and the reasons why you like them here.

LITTLE MISS MUFFET (1989)

In this picture, the nursery rhyme character Little Miss Muffet sits next to a spider that looms up behind her. Rego has turned the spider into a larger-than-life being with a human face. All her nursery rhyme pictures seem to point to the darker, more threatening side of children's stories.

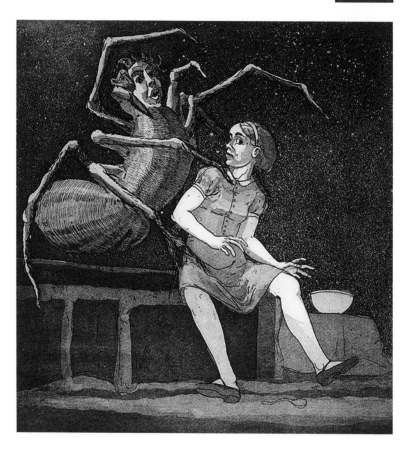

Why do you think Rego has given the spider a human face?

Write down some words that could describe the way Miss Muffet is feeling.

Pick a character from one of your favourite books. It doesn't have to be the hero.
What do you like about them?

What don't you like?

What actions do they take?

Are they brave?

Do they get anything wrong?

Does anything interesting happen to them?

David Hockney

'I've always believed that pictures
make us see the world more clearly.'

Born in 1937, David Hockney studied art in Bradford, UK, and at the Royal College of Art in London, where he became a leading figure in the **pop art** scene in Britain. In 1964, he decided to move to **California** in the USA. Inspired by the light, the lifestyle and the art he found there, he began painting in bold, bright colours. His pictures often included the swimming pools and modern houses, rolling hills and winding roads he saw all around him.

In the late 1990s Hockney moved back to the UK and started visiting the **East Yorkshire countryside** where he grew up. Since then, he has produced a series of huge **landscape** pictures, some several metres high.

Hockney's work is always evolving, as his interest in art history and other artists inspire him to keep working in new ways. Moving between painting, photography, illustration, stage design and work on the computer, he is always keen to explore new **technology.** He has used Polaroid photographs, photocopiers, fax machines, digital photographs, computers and – most recently – iPhones and iPads to make his work.

BRIGHT

JOYOUS

THOUGHTFUL

PORTRAIT OF HIS FRIENDS

A BIGGER SPLASH (1967)

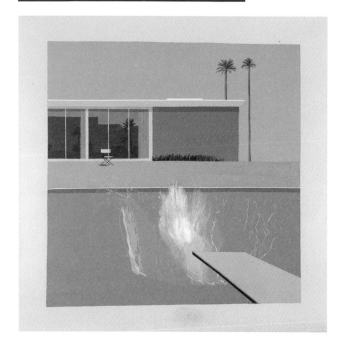

This is a picture of the splash the water makes after the person has dived in. In a way, it's a portrait of someone who isn't in the picture.

MR AND MRS CLARK AND PERCY (1970-1)

Look closely:

There's also a picture within the picture - on the wall is another of Hockney's own works.

Percy is the name of the couple's cat.

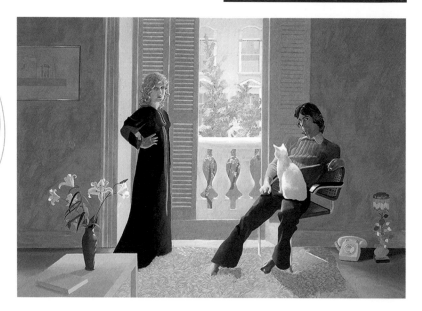

Look at *Mr and Mrs Clark and Percy*. What details can you see in the painting? List all the
objects you can see. What might each of them tell you about the couple in the picture?

Hockney's friends, Ossie Clark and Celia Birtwell (the couple in the picture),
were both fashion designers. Look at the contrasting fabrics in the picture — how many
different textures can you see? Write some words to describe them.

CHANGING PLACES

Hockney likes to paint the woods, fields and country lanes near his home in East Yorkshire, noticing the way they change throughout the year. He goes back again and again to the same spot to capture the seasons changing and paint the different effects in the woods, trees and fields.

Choose a place you like to visit again and again, or a view you look at every day. Does it look different as the months pass?

Try taking photographs or drawing it at different times.

'I'm dead serious
about being nonsensical.'

As a boy, Ed Ruscha was keen on drawing and painting, collecting stamps and coins and creating his own cartoons. At the age of eighteen, he and a friend set off in his car and drove across the USA. They ended up at art school in Los Angeles, California. While studying there, Ruscha had various jobs working for a printer, painting signs and designing magazines.

Los Angeles, home of the Hollywood film industry, was a very different place from Oklahoma, where Ruscha grew up. Inspired by the colourful billboard signs he saw all around him, he began making paintings and drawings full of **words**. He used different **typefaces** and experimented with different styles of **lettering**.

Ruscha carried a camera around with him, and started taking **photographs**, which he made into **books**. Each was inspired by a single idea. His first, *Twentysix Gasoline Stations*, was just that – a collection of black-and-white photographs of twenty-six petrol stations. Ruscha also experimented with making art from different materials, including food and unusual liquids. In 1973, he created a room wallpapered with chocolate-covered sheets of paper!

WORDS, WORDS, WORDS

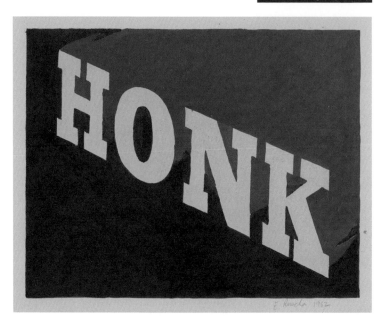

Honk makes us think of the loud noise of traffic – perhaps Ruscha was inspired by the busy streets of Los Angeles.

Ruscha often finds words for his pictures by jotting down words spoken in films or on the radio. He's interested in different typefaces, and how words can be arranged on the page. Sometimes he puts them against blank backgrounds, sometimes against a picture.

HONK
BOSS
OOF
LISP
ACE
SMASH
NOISE
POOL

Some of the words used by Ruscha in his paintings and drawings

Make a list of some words you like here. You could choose them because of the shape of the letters, or the sound they make — or both!

Ruscha experimented with different type styles, including words
that looked as if they had been 'poured' onto the canvas and some that appeared
to have been 'folded' or 'curled' from cut pieces of paper.

Find some words in a newspaper, in different shapes and sizes.
Cut out your favourites and use them to create a picture.
You could also experiment with drawing some typefaces of your own.

OUT ON THE STREET

EVERY BUILDING ON THE SUNSET STRIP (DETAIL) (1966)

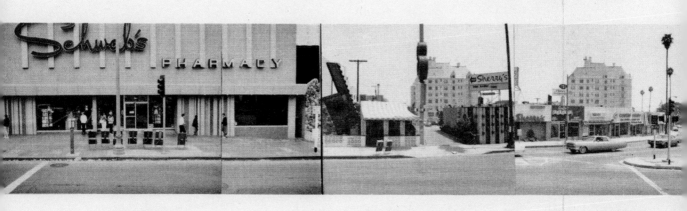

8024 Sunset 8100 8106 8108 Crescent Hts.

Ruscha wanted to make a book that contained photographs of every building on the 'Sunset Strip', part of Los Angeles' most famous street, Sunset Boulevard. To do this, he attached a camera to a moving car, capturing all the houses, shops and businesses as he drove down the street.

Things Ruscha photographed

> Petrol stations
> Palm trees
> Buildings
> Swimming pools
> Street signs
> Views from the air
> Logos and brands
> Street names
> Los Angeles landmarks, like the Hollywood sign

Ruscha wanted to record everything he saw, and didn't want to overlook any detail. Think about the street where you live. Describe what you can see. Make a note of every detail — however small!

On a car, bus or train journey or on your walk to school, make a list of the things you see on the way, such as shops, restaurants, trees, signs or cars.

Cindy Sherman

'When I look at the pictures,
I never see myself;
they aren't self-portraits.
Sometimes I disappear.'

The American artist Cindy Sherman grew up in Long Island, New York. She studied painting at first, but soon took up **photography**.

In her work, she photographs herself in different poses. By wearing **make-up** and **costumes** she creates new **characters** for each picture, as if she were in a film or play. Her photographs show that our appearance says so much about us – people look for clues to work out what we are like. But, of course, these signs can also be misleading!

Sherman's early pictures were in **black and white**. To make them, she looked for clothes in her own wardrobe and scoured local charity shops. In later works, Sherman began to work in **colour** and set up more elaborate scenes. The photographs cause us to question how we 'read' images in the pictures we see every day in magazines, fashion advertisements, cinema and the news. We shouldn't always believe what we see!

PHOTOGRAPHIC

THEATRICAL

STORYTELLING

DRESSING UP

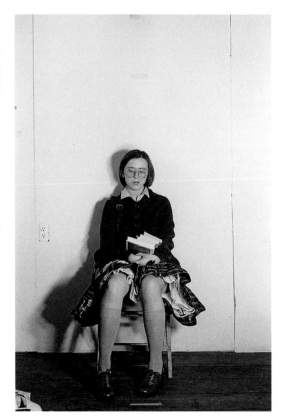 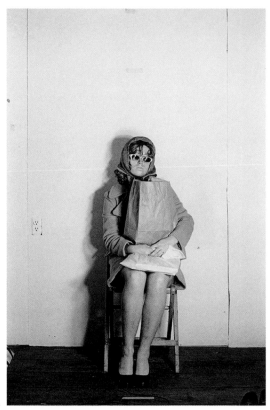

The fifteen characters in the Bus Riders series all look different, but in fact they are all pictures of the same person - the artist Cindy Sherman. They are posing in the same position, on a wooden chair facing the camera. It's as if they are sitting on a seat on the bus. Sherman hasn't tried to hide the way the pictures have been set up - they are clearly made in a studio (it's even possible to see cables and a foot pedal that operates her camera).

Do you have clothes in your wardrobe that you could use to create unusual characters?

90

Imagine you are the character in one of the pictures opposite.

Write a little bit about yourself.

What's your name? Where do you live?

Where are you going on the bus?

Make a list of the characters you'd like to play, if you were creating a series

of pictures like Sherman's.

Make them as different as possible.

WHAT'S THE STORY!

Between 1979 and 1980 Sherman made a series of sixty-nine photographs known as *Untitled Film Stills*. In each one, she's dressed in a new outfit, and is in a different place. Some were taken outside in country locations, or in the city; others are set inside; some are close-ups, and others, like the pictures below, have been taken outdoors.

UNTITLED FILM STILL #48 (1979)

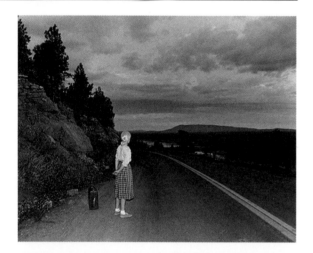

Looking at these pictures, we can invent different stories.

Who are these characters?
What are they doing?
What's going to happen to them next?

UNTITLED FILM STILL #17 (1978)

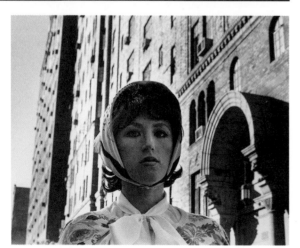

Here, with her head covered by a scarf, Cindy Sherman plays a woman walking alone in a big city.

Sherman has said, 'Some people have told me they remember the film that one of my images is derived from, but in fact I had no film in mind at all.'

Why do you think people might make this mistake?

Choose one of the characters opposite.

What sort of film might they be starring in?

Give your film a title, and design a poster for it here.

Rachel Whiteread

'I simply found a wardrobe . . .
I stripped the interior . . .
turned it on its back, drilled some holes
in the doors and filled it
with plaster until it overflowed.'

Rachel Whiteread makes sculptures of the spaces underneath, around or in-between objects. Instead of copying what's there, she focuses on what isn't there – it's as if she's making **empty space** and air **solid**. Her first sculptures were of things she found in her home. She made them by pouring **plaster** inside her wardrobe, underneath her mattress and inside her hot water bottle. This process is called '**casting**'. Next, she made *Ghost*, a cast of a whole room.

After this, Whiteread started working on a much bigger scale with a large team of people. For her sculpture *House* she found a terraced house in east London that was going to be demolished. First, she filled the inside of the house with concrete. This took over a month! Once the concrete had set hard, scaffolding was set up and she removed the walls. A sculpture of the empty space inside remained (many people were furious that it was destroyed a year later). Since then, Whiteread has been asked to create other works in **outdoor spaces** across the world.

MONUMENTAL

ARCHITECTURAL

SCULPTURAL

MAKING A SCULPTURE

Whiteread has experimented with many different materials to make her works, including plaster, rubber, resin and concrete. When she pours them, they are liquid, but, after a few hours (or sometimes longer), they set and become hard. To make her larger sculptures, she works in sections, and many separate parts have to be fixed together to create the final piece.

Make a list of materials you might use to make a sculpture. What do you like about each one?

Think about how these sculptures might feel to touch.

UNTITLED (NINE TABLES) (1998)

In this work, nine rectangular concrete blocks are spaced neatly in three rows. They are actually sculptures of the spaces underneath the tables in the title!

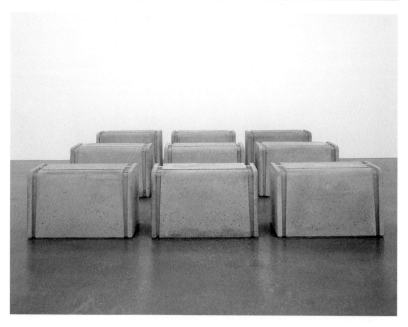

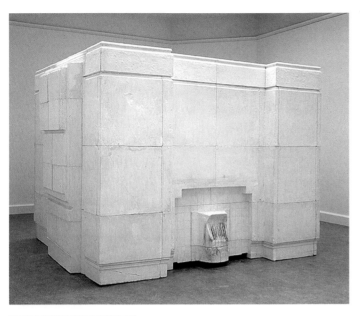

GHOST (1990)

In 1990, Whiteread decided to make a cast of a whole room. She called the finished sculpture *Ghost*. She chose the living room of a house in north London, which was very close to where she grew up. This was challenging work. She had to cast it in sections, and afterwards put all the sections together to make the finished work. The final sculpture was of a 'room' that was totally sealed up – no-one could enter. Up close, you could still see traces of soot in the grate around the fireplace.

Why do you think Whiteread called her sculpture *Ghost*?

Can you think of any other titles for the work?

THE SPACES AROUND YOU

Whiteread has been inspired by the objects and spaces in her home, in her studio and in the area where she lives.

Look around your own home. Make a list of objects or pieces of furniture in your living room, kitchen or bedroom. Can you imagine the spaces beneath or inside them becoming solid? Which objects do you think would look most different? Sketch some of them here.

Whiteread once made a set of drawings of the patterned flooring in her apartment. Can you see any patterns around your house or outside? Look at tiles, woodwork or the shapes of windows.

DAMIEN HIRST

'Every work
that has ever interested me
is about death.'

The young Damien Hirst loved collecting things – first rocks, then art books and medicine textbooks. When he was a student at Goldsmiths College in London, he organised an exhibition with his classmates called 'Freeze' in an old warehouse in London's docklands. His work soon became known around the world for presenting daring ideas in a dramatic way.

In 1991, an exhibition containing Hirst's most famous work made the headlines of national newspapers. Hirst had suspended a four-metre-long Australian **tiger shark** in a huge steel and glass tank filled with formaldehyde. This chemical preserved it and stopped it from rotting.

Scientists in the nineteenth century often presented stuffed animals, skeletons and weird and wonderful objects in glass cabinets. Hirst is fascinated by such displays and has continued to make work using **cabinets** and **boxes** filled with **animals** and **bones**. He has also included living and dead **butterflies** and **flies** in his work. As well as making art, Hirst is a **collector** of curious objects and work by other artists. He has even opened a museum to show his collection.

LOUD

SHOCKING

CONTROVERSIAL

LIFE AND DEATH

What has Damien Hirst included in his work?

> Cabinets and display cases – filled with objects in neat rows
> Stuffed animals and skeletons
> Skulls and bones
> Shells and rocks
> Medicines and their packaging
> Butterflies – both living and dead
> Office furniture

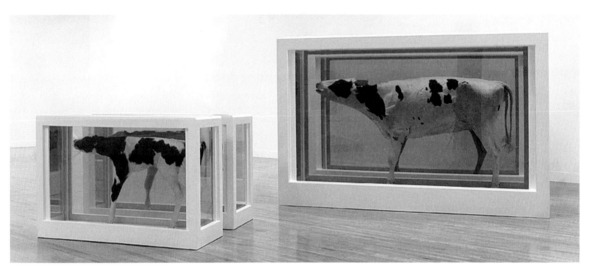

MOTHER AND CHILD (DIVIDED) (2007)

In this work, a cow and calf – each perfectly sliced in half, to reveal their insides – are displayed in four glass tanks. Imagine being able to see inside your own body!

Look through some magazines (try ones about animals or natural history), furniture catalogues and newspapers. Cut out some interesting pictures and arrange them in groups.

You could fill a folder with the pictures you've found.

Hirst's work often relates to life and death. He made his first 'medicine cabinet' work while at university, using his grandmother's empty medicine boxes.
In 1992, he created a complete pharmacy in the room of a gallery. At first glance, it didn't look like a work of art at all! Cabinets filled with medicine packaging lined the walls. The piece also included a counter and swivel chairs - a place for the pharmacist to sit. Hirst once said that he walked into an actual pharmacy and was impressed by the way it looked - in a way, it was a perfect work of art.

Hirst's Pharmacy included medicines for all kinds of illnesses.

Can you make up names for medicines you might take for different conditions — for example, a headache? Design the packaging here.

DIAMONDS AND BONES

Hirst had the teeth cleaned by a dentist while he was making the sculpture.

In 2007, Hirst made a work called *For the Love of God*. It's a cast of a real skull made in platinum and decorated with 8,601 precious diamonds. That's a lot of diamonds! They make it one of the most expensive pieces of art ever made.

Like many of Hirst's works, this piece confronts the idea of death. Hirst felt that people tried to disguise or decorate death because they don't like it and it makes it bearable.

Hirst bought the original skull from a taxidermy shop in London before making the cast. He wanted to find out more about it and tests revealed that it probably belonged to a 35-year-old man who lived from around 1720-1810.

Imagine this man's life. What do you think he did? Where do you think he lived?

Did he have a family? How did he die?

Create a story for him here.

WHO DID WHAT AND WHEN?

Below you will find a short biography of the featured artists along with where to see the artworks illustrated in this book. Other works by these artists can be found in gallery collections throughout the world. Try searching for them on your local gallery's website and see what you can find.

PAUL KLEE was born on 18 December 1879 in Münchenbuchsee near Bern in Switzerland. He loved colour and wrote about it all the time. Several art styles that were blossoming during his lifetime — including cubism (see page 14) and surrealism (see page 26) — influenced his drawing, painting and printmaking. He died on 29 June 1940 at the age of sixty in Muralto in Switzerland.

Page 8
Pictorial Architecture Red, Yellow, Blue, 1923
Oil paint on cardboard, 443 × 340 mm
Zentrum Paul Klee, Bern, Switzerland

Page 10
Ships in the Dark, 1927
Oil paint on canvas, 427 × 590 mm
Tate, UK

Page 11
Comedy, 1921
Watercolour and oil paint on paper,
305 × 454 mm
Tate, UK

PABLO PICASSO was born on 25 October 1881 in Málaga in Spain, but spent most of his life working in France. It is believed that he made around 50,000 works of art during his long career! These include paintings, drawings, prints, sculpture, ceramics and tapestries. When he died on 8 April 1973 at the age of ninety-one in Mougins, France, he was one of the most famous artists in the world.

Page 14
Bowl of Fruit, Violin and Bottle, 1914
Oil paint on canvas, 920 × 730 mm
Tate, UK

Page 16
Weeping Woman, 1937
Oil paint on canvas, 608 × 500 mm
Tate, UK

MARCEL DUCHAMP was born on 28 July 1887, in Blainville-Crevon, in northern France. Even though his cubist (see page 14) painting created a sensation in 1913 and made him famous, Duchamp did very little painting after that and began creating 'readymades' instead (see page 19). Duchamp was hugely influential and his works often included a sense of fun, witty wordplay as well as always asking the question 'what is art?'. He died at the age of eighty-one on 2 October 1968 in the Parisian suburb of Neuilly-sur-Seine.

Page 20
Fountain, 1917 (replica 1964)
Porcelain, 360 × 480 × 610 mm
Tate, UK

Page 22
Box in a Valise (Boîte-en-Valise), 1935—41
(contents); deluxe edition, Series A, 1943
Brown leather valise with handle,
406 × 375 × 108 mm
Philadelphia Museum of Art, PA, USA

RENÉ MAGRITTE was born on 21 November
1898 in Lessines in Belgium. Magritte is best
known as a surrealist artist (see page 26).
He created many intriguing paintings with a
comical twist by putting familiar everyday
objects in unexpected situations and turning
the ordinary into the extraordinary. He died
on 15 August 1967 at the age of sixty-eight in
Brussels, Belgium.

Page 26
The Reckless Sleeper, 1928
Oil paint on canvas, 1160 × 810 mm
Tate, UK

Page 28
The Empire of Light, 1954
Oil paint on canvas, 1460 × 1140 mm
Musées Royaux des Beaux-Arts de Belgique,
Brussels, Belgium

JOSEPH CORNELL was born in Nyack,
New York, on 24 December 1903. He spent most
of his adult life living with his mother and
brother Robert in Queens, New York. Working
in the family home, Cornell created his own
style of art. Influenced by the work of surrealist
artists (see page 26) he combined objects,
photographs and magazine cuttings from
his own collection to create elaborate 'box'
sculptures. Cornell died at home on December
29 in 1972 at the age of sixty-nine.

Page 34
Untitled (Hôtel de la Duchesse-Anne), 1957
Box construction, 448 × 311 × 113 mm
The Art Institute of Chicago, IL, USA

Page 36
*Planet Set, Tête Etoilée, Giuditta Pasta
(dédicace)*, 1950
Glass, crystal, wood and paper, object,
305 × 457 × 102 mm
Tate, UK

FRIDA KAHLO was born on 6 July 1907 in
Coyoacán in Mexico. After being badly injured in
an accident at the age of eighteen, Kahlo took
up painting from her bed. Inspired by Mexican
folklore, she created bold, unique paintings and
is now regarded as one of the most significant
artists of the twentieth century. She died on 13 July
1954 in Coyoacán, Mexico, aged just forty-seven.

Page 40
Self-Portrait with Monkey, 1938
Oil paint on masonite, 407 × 305 mm
Collection Albright-Knox Art Gallery,
Buffalo, NY, USA

Page 42
Self-Portrait Dedicated to Dr Eloesser, 1940
Oil paint on masonite, 565 × 400 mm
Private collection

LOUISE BOURGEOIS was born on 25 December 1911 in Paris, France. At first she studied mathematics but soon took up painting, and her early pictures were inspired by surrealism (see page 26). After moving to New York, she took up sculpture and made bold works involving themes of family, emotions and memories. Bourgeois continued making art right up till her death aged ninety-eight on 31 May 2010 in Manhattan, New York City.

Page 46
Cell (Eyes and Mirrors), 1989—93
Steel, limestone and glass,
2362 × 2108 × 2184 mm
Tate, UK

Page 48
Drawing based on the sculpture *Maman*, 2008
Steel and marble, 9271 × 8915 × 10,236 mm
Tate, UK

ANDY WARHOL was born on 6 August 1928 in Pittsburgh, Pennsylvania, USA. He moved to New York City to work in advertising, but soon became a leading figure in the movement known as pop art (see page 54). In his New York studio, known as the Factory, Warhol produced hundreds of paintings of celebrities, supermarket products and images from comics and cartoons. He died on 22 February 1987 in New York City aged fifty-eight.

Page 54
Heinz Tomato Ketchup Box [Prototype], 1963—4
Silkscreen on wood, 267 × 394 × 267 mm
Museum of Modern Art, New York, USA

Page 57
Black Bean, 1968
Screenprint on paper, 892 × 591 mm
Tate, UK

YAYOI KUSAMA was born in Matsumoto in Japan on 22 March 1929. In 1957 she moved to the USA and settled in New York where she created bold paintings, sculptures and performances. Her work frequently involves brightly coloured polka dots, and often takes the form of rooms that audiences can enter and explore. In 1973 Kusama moved back to Japan, where she is still making work today.

Page 61
Infinity Mirrored Room — Filled with the Brilliance of Life, installed for the exhibition *Yayoi Kusama at Tate Modern*, 2012

Page 62
Yayoi Kusama with 'Dots Obsession', 2011, an installation in her solo exhibition *Kusama's Body Festival in the 60's* at the Watari Museum of Contemporary Art, Tokyo, Japan

BRIDGET RILEY was born on 25 April 1931 in London and studied at Goldsmiths College and the Royal College of Art. After experimenting with different ideas, she developed her own style, making abstract paintings (see page 8) that explore the way different shapes affect our eyes when we look at the canvas. Her use of patterns and colours give a special effect to her paintings, almost like the images are vibrating or moving.

Page 66
Fall, 1963
Polyvinyl acetate paint on hardboard,
1410 × 1403 mm
Tate, UK

Page 68
Nataraja, 1993
Oil paint on canvas, 1651 × 2277 mm
Tate, UK

PAULA REGO was born on 26 January
1935 in Lisbon, Portugal. She studied at the
Slade School of Fine Art in London where she
was taught painting and printmaking. Rego's
pictures often involve dark twists on nursery
rhymes, classic stories and folk tales from
her native Portugal. In 2009 a museum
dedicated to Rego's work was opened in
Lisbon, called the 'House of Stories'.

Page 72
The Dance, 1988
Acrylic paint on paper on canvas,
2126 × 2740 mm
Tate, UK

Page 74
Little Miss Muffet, 1989
Etching with aquatint, 520 × 380 mm
Marlborough Fine Art, London, UK

DAVID HOCKNEY was born in Bradford,
Yorkshire, UK, on 9 July 1937. He has lived in
London, California and Yorkshire and his art
clearly reflects these different locations, be it
the swimming pools of Los Angeles or the trees
of the Yorkshire Wolds. Heavily involved in pop
art (see page 54), he is now considered one
of the most influential British artists of the
twentieth century.

Page 78 (top)
A Bigger Splash, 1967
Acrylic paint on canvas, 2425 × 2439 mm
Tate, UK

Page 78 (bottom)
Mr and Mrs Clark and Percy, 1970–1
Acrylic paint on canvas, 2134 × 3048 mm
Tate, UK

ED RUSCHA was born on 16 December 1937
in Omaha, Nebraska, USA and his work includes
drawing, painting, printmaking, photography
and film. He grew up in Oklahoma but later
moved to Los Angeles. Here, he was inspired by
the colours and lights of advertisement signs
and began making art using words and slogans
for which he is now famous.

Page 84
HONK, 1962
Acrylic paint on paper, 279 × 352 mm
Tate, UK

Page 86
Every Building on the Sunset Strip, 1966 (detail)
Printed book, 185 × 147 mm
Tate, UK

CINDY SHERMAN was born on 19 January 1954 in New Jersey in the USA but grew up in Long Island, New York. She is known for her experimentation with photography and for telling stories, using costumes, make-up and wigs to create lots of different characters, all of which she played herself.

Page 90 (left and right)
Untitled, 1976, from the 'Bus Riders' series
Gelatin silver print on paper, 189 × 127 mm
Tate, UK

Page 92 (top)
Untitled Film Still #48, 1979, reprinted 1998
Gelatin silver print on paper, 710 × 955 mm
Tate, UK

Page 92 (bottom)
Untitled Film Still #17, 1978, reprinted 1998
Gelatin silver print on paper, 745 × 950 mm
Tate, UK

RACHEL WHITEREAD was born in London in 1963. She creates sculptures of the spaces underneath, around or in-between objects, using materials such as plaster, resin and concrete to fill in the gaps. In 1993 she became the first woman to win the Turner Prize for her work *House* (see page 95). Her work often involves casting whole rooms or buildings and turning them into sculptures. She even cast her own house, which used to be a synagogue.

Page 96
Untitled (Nine Tables), 1998
Concrete and polystyrene,
681 × 3750 × 5190 mm
Tate, UK

Page 97
Ghost, 1990
Plaster on steel frame overall:
2690 × 3555 × 3175 mm
National Gallery of Art, Washington, D.C., USA

DAMIEN HIRST was born in Bristol, UK, on 7 June 1965. He is one of Britain's most famous living artists, as well as being a businessman and art collector. His work has caused controversy because of his use of unusual materials such as preserved animals, flies and even rotting meat! He has also used some very precious materials such as gold and diamonds.

Page 102
Mother and Child (Divided), exhibition copy 2007 (original 1993)
Glass, stainless steel, Perspex, acrylic paint, cow, calf and formaldehyde solution,
2 parts: 2086 × 3225 × 1092 mm,
1136 × 1689 × 622 mm
Tate, UK

Page 104
For the Love of God, 2007
Platinum, diamonds and human teeth,
171 × 127 × 191 mm
Private collection

PICTURE CREDITS

BI, ADAGP, Paris/ Scala, Florence p.28

Albright Knox Art Gallery/ Art Resource, NY/ Scala, Florence p.40

The Art Institute of Chicago/ Gift of the Joseph and Robert Cornell Memorial Foundation/ Bridgeman Images p.34

Courtesy the artist p.97

Courtesy the artist. Photo: Prudence Cuming Associates p.104

Courtesy the artist and Metro Pictures, New York pp.90 (both), 92 (both)

Courtesy Marlborough Fine Art p.74

Museum of Modern Art, New York/ Scala, Florence p.54

Courtesy Ota Fine Arts, Tokyo/ Singapore; Victoria Miro Gallery, London; David Zwirner, New York p.62

Philadelphia Museum of Art/ Art Resource/ Scala, Florence p.22

Pictures from History/ Bridgeman Images p.42

© Tate, UK 2017 pp.10, 11, 14, 16, 20, 26, 36, 46, 57, 61, 66, 68, 72, 78 (both), 84, 86, 96, 102

© Zentrum Paul Klee p.8

COPYRIGHT CREDITS

All works © the artist unless otherwise stated below:

© Banco de México Diego Rivera Frida Kahlo Museums Trust, Mexico, D.F./ DACS 2017 pp.40, 42

Louise Bourgeois © The Easton Foundation/ VAGA, New York/ DACS, London 2017 pp.46, 48

© The Joseph and Robert Cornell Memorial Foundation/ VAGA, NY/ DACS, London 2017 pp.34, 36

© Damien Hirst and Science Ltd. All rights reserved, DACS 2017 pp.102, 104

René Magritte © ADAGP, Paris and DACS, London 2017 pp.26, 28

© Paula Rego, courtesy Marlborough Fine Art pp.72, 74

© Succession Marcel Duchamp/ ADAGP, Paris and DACS, London 2017 pp.20, 22

© Succession Picasso/ DACS, London 2017 pp.14, 16

© 2017 The Andy Warhol Foundation for the Visual Arts, Inc./ Artists Rights Society (ARS), New York and DACS, London pp.54, 57

For Arlo, Zubin, Quincy and Viola — get scribbling!

First published 2017 by order of the Tate Trustees
by Tate Publishing, a division of Tate Enterprises Ltd,
Millbank, London SW1P 4RG
www.tate.org.uk/publishing

Text and illustrations © Mary Richards 2017

A catalogue record for this book is available from the
British Library

ISBN 978 1 84976 450 6

Distributed in the United States and Canada by ABRAMS,
New York

Library of Congress Control Number applied for

Designed by Lizzie Ballantyne

Colour reproduction by Evergreen Colour Management Ltd,
Hong Kong

Printed in China by Toppan Leefung Printing Ltd

MIX
Paper from
responsible sources
FSC
www.fsc.org FSC® C104723